INSTANT PRINT CAMERA FOR KIDS USER GUIDE

A Step by Step Manual for Easy Understanding

GEORGE MEDLIN

TABLE OF CONTENTS

INTRODUCTION

Imagine being able to take a picture and see it instantly, right in front of your eyes. No more waiting for photos to develop or printing them out. With your instant print camera, you can create tangible keepsakes that you can hold, share, and treasure forever.

What can you do with your instant print camera?

- Capture precious moments: From birthday parties and family gatherings to school events and vacations, your camera can help you preserve the special moments in your life.
- Express your creativity: Experiment with different angles, poses, and backgrounds to create unique and artistic photos.

- Decorate your space: Hang your favorite photos on your wall, stick them in a scrapbook, or give them as gifts to friends and family.
- Share your memories: Show off your photos to your friends and family, or even share them online.
- Have fun! Instant print cameras are a great way to have fun and be creative.

So, what are you waiting for? Let's get started! In the next section, we'll learn how to set up your camera and take your first picture. Get ready to unleash your inner photographer!

SETTING UP YOUR INSTANT PRINT CAMERA: A STEP-BY-STEP GUIDE

1. Unboxing Your Camera:

- Carefully open the box and remove your new camera.
- Check that everything is included in the box: the camera itself, the film cartridge, the battery, and the charging cable.

2. Inserting the Film Cartridge:

- Locate the film cartridge slot on the back of the camera.
- Open the slot and carefully insert the film cartridge, making sure it's aligned correctly.
- Close the slot securely.

3. Inserting the Battery:

- Find the battery compartment, usually located on the bottom of the camera.
- Open the compartment and insert the battery, ensuring the positive and negative terminals are aligned correctly.
- Close the compartment.

4. Charging the Battery:

- Connect the charging cable to the camera and then to a power source.
- The charging indicator light will usually light up to show that the battery is charging.
- Allow the battery to charge fully before using the camera.

5. Loading the Film:

- Once the battery is charged, the camera is ready to be loaded with film.
- Open the film cartridge slot again.
- Pull out the film leader and insert it into the designated slot on the camera.
- Close the slot.

6. Winding the Film:

- Turn the film rewind knob on the back of the camera until you hear a clicking sound. This winds the film to the first frame.

7. Setting the Date and Time:

- Locate the date and time settings on your camera.
- Follow the instructions in your camera's manual to set the correct date and time.

8. Taking Your First Picture:

- Turn on the camera by pressing the power button.
- Point the camera at your subject and frame the shot.
- Press the shutter button to take the picture.
- Your photo will develop instantly and appear from the camera's slot.

9. Ejecting the Film Cartridge:

- When the film cartridge is empty, you'll need to eject it.
- Follow the on-screen instructions or refer to your user manual for specific steps.

Congratulations! You've successfully set up your instant print camera and are ready to start taking pictures. Remember to experiment with different settings and techniques to find your own unique

style. Have fun and enjoy capturing memories with your new camera!

MASTERING YOUR INSTANT PRINT CAMERA: TIPS FOR TAKING GREAT PHOTOS

1. Focusing on the Subject:

- What is focusing? Focusing means making sure your camera is pointed at the right spot so the picture is clear and sharp.
- How to focus:
 - Manual focus: Some cameras have a manual focus ring. Turn the ring until the subject is sharp in the viewfinder.
 - Autofocus: Most modern cameras have autofocus. Simply point the camera at the subject and press the focus button halfway down. The

camera will automatically adjust the focus.

- Tips for focusing:
 - Use the center focus point: Many cameras have a center focus point that is more accurate. Try focusing on the subject using the center point.
 - Lock the focus: Once you've focused on your subject, you can lock the focus by pressing the shutter button halfway down and holding it. This will prevent the camera from refocusing as you compose the shot.

2. Using the Flash Wisely:

- When to use the flash: Use the flash in low-light conditions or when you want to fill in shadows.

- When to avoid the flash: Avoid using the flash in bright sunlight or when taking pictures of people against a bright background, as it can create harsh shadows.
- Flash settings:
 - Auto: The camera will automatically decide whether to use the flash based on the lighting conditions.
 - On: The flash will always be used, regardless of the lighting conditions.
 - Off: The flash will never be used.

- Tips for using the flash:
 - Bounce the flash: If your camera has a built-in flash, try bouncing it off the ceiling or a wall to create a softer and more natural light.

○ Use an external flash: For more control over your lighting, consider using an external flash that can be mounted on a tripod or held in your hand.

3. Taking Perfect Selfies:

- Find the right angle: Experiment with different angles to find the most flattering one.
- Use the selfie timer: Set the timer on your camera so you have time to get into position and strike a pose.
- Use natural light: Whenever possible, take selfies in natural light. Avoid harsh shadows by facing towards a window or going outside.

- Accessorize: Add some fun accessories to your selfies, such as sunglasses, hats, or props.

4. Framing the Shot:

- Rule of thirds: Divide your image into nine equal parts using two horizontal and two vertical lines. Place the most important elements of your photo at the intersections of these lines.
- Leading lines: Use lines in your composition to guide the viewer's eye towards the main subject.
- Background: Pay attention to the background of your photo. A cluttered background can distract from the main subject.

- Fill the frame: Get close to your subject and fill the frame with them. This will create a more impactful image.

By following these tips, you can take amazing photos with your instant print camera and capture your memories in a unique and creative way. Experiment with different techniques and have fun!

DEVELOPING AND PRINTING

Imagine a magical machine that can turn invisible pictures into real, touchable works of art. That's what a photo printer does! It's like a printing press, but instead of printing words, it prints pictures.

The Ink of Light

When you take a picture with your camera, you're capturing a special kind of ink: the ink of light. This invisible ink is stored inside the tiny grains of your film or digital sensor.

The Magical Paper

To turn the ink of light into a picture, you need a special kind of paper. This paper is coated with chemicals that react to the light. It's like a blank

canvas waiting for the artist to paint a masterpiece.

The Printing Press

The photo printer is like a magical printing press. It takes the ink of light from your camera and transfers it onto the special paper. The chemicals on the paper react to the light, creating the picture you see.

The Developing Process

Just like a magician needs to perform a special spell to reveal the hidden image, the photo printer needs to go through a process called developing. This is when the chemicals on the paper are activated and the hidden image appears.

The Magic of Light

The light from the printer is like a magic wand that brings the hidden image to life. It interacts with the chemicals on the paper, creating the colors and details of the picture.

The Final Touches

After the developing process is complete, the printer may need to add some final touches. This could include drying the picture, trimming it to the right size, or adding a border.

The Magic of a Printed Photo

Once the picture is finished, you can hold it in your hands and admire the magic that has been created. It's like a piece of art that you can touch and feel.

CARING FOR YOUR CAMERA

1. Battery Care:

- Regular charging: Keep your camera's battery fully charged whenever possible. A drained battery can affect the camera's performance and lifespan.
- Avoid overcharging: Overcharging can damage the battery. Disconnect the charger once the battery is fully charged.
- Store properly: When storing the camera for extended periods, remove the battery and store it in a cool, dry place.

2. Cleaning the Lens:

- Use a microfiber cloth: Gently wipe the lens with a clean, microfiber cloth to remove smudges or fingerprints.

- Avoid harsh chemicals: Never use alcohol, solvents, or other harsh chemicals to clean the lens, as they can damage the lens coating.
- Protect the lens: Use a lens hood to shield the lens from dust, scratches, and accidental impacts.

3. Cleaning the Body:

- Wipe with a soft cloth: Gently wipe the camera's body with a soft, dry cloth to remove dust and fingerprints.
- Avoid moisture: Keep the camera away from moisture and humidity. If the camera gets wet, turn it off immediately and let it dry completely before using it again.

4. Storing the Camera:

- Store in a cool, dry place: Keep the camera in a cool, dry environment to prevent moisture damage.

- Avoid extreme temperatures: Avoid exposing the camera to extreme temperatures, such as hot cars or cold weather.

- Use a protective case: Store the camera in a protective case to shield it from scratches, dust, and accidental bumps.

5. Troubleshooting Common Issues:

- Camera won't turn on: Check the battery level and ensure it's properly inserted. If the battery is fully charged and inserted correctly, try resetting the camera.

- Blurry photos: Ensure the camera is focused correctly. Check the lens for smudges or fingerprints. If the problem

persists, try using a tripod to stabilize the camera.

- Camera freezes: If the camera freezes, try turning it off and on again. If the problem persists, it may be necessary to reset the camera or seek professional assistance.

6. Regular Maintenance:

- Check for loose screws: Periodically check for any loose screws on the camera and tighten them if necessary.
- Update firmware: Keep your camera's firmware up-to-date to improve performance and address any known issues.
- Professional cleaning: If your camera is heavily soiled or has sustained damage, consider having it professionally cleaned or repaired.

By following these tips, you can help ensure that your camera remains in optimal condition and provides you with many years of enjoyment. Remember, prevention is key when it comes to camera maintenance.

TROUBLESHOOTING: SOLVING YOUR PHOTO PROBLEMS

1. Blurry Pictures:

- Problem: Your pictures are blurry and hard to see.
- Solution:
 - Check the focus: Make sure you're pressing the focus button halfway down before taking the picture.
 - Hold still: Try to hold the camera very still when taking the picture. A shaky camera can make the picture blurry.
 - Use a tripod: A tripod is a special stand that helps you hold the camera perfectly still.

2. Dark Pictures:

- Problem: Your pictures are too dark.
- Solution:
 - Turn on the flash: The flash can help make your pictures brighter.
 - Use a higher ISO: The ISO setting controls how sensitive your camera is to light. A higher ISO can help make your pictures brighter, but it can also make them a little grainy.
 - Open the aperture: The aperture is like the pupil in your eye. A wider aperture lets in more light.

3. Bright Pictures:

- Problem: Your pictures are too bright.
- Solution:

- Turn off the flash: If the flash is on, try turning it off.
- Use a lower ISO: A lower ISO can help make your pictures darker.
- Close the aperture: A smaller aperture lets in less light.

4. Red Eyes:

- Problem: People in your pictures have red eyes.
- Solution:
 - Turn off the flash: The flash can cause red eyes. Try using natural light or a different lighting setup.
 - Use the red-eye reduction feature: Some cameras have a special feature that helps prevent red eyes.

5. Camera Won't Turn On:

- Problem: Your camera won't turn on.
- Solution:
 - Check the battery: Make sure the battery is fully charged and inserted correctly.
 - Try resetting the camera: Sometimes, resetting the camera can fix problems. Check your camera's manual for instructions on how to reset it.

6. Camera Freezes:

- Problem: Your camera freezes and stops working.
- Solution:

o Remove the battery: Sometimes, removing the battery for a few minutes can help reset the camera.

o Check for software updates: Make sure your camera's software is up-to-date.

7. Camera Takes a Long Time to Focus:

- Problem: Your camera takes a long time to focus on the subject.

- Solution:

 o Clean the lens: Smudges or fingerprints on the lens can make it harder for the camera to focus.

 o Use a faster lens: A faster lens has a wider aperture, which can help the camera focus more quickly.

If you're still having trouble with your camera, check the user manual or ask an adult for help.

ADDITIONAL TIPS

1. The Camera's Best Friend: A Case

- Why it's important: Just like you protect your favorite toy, your camera needs a case to keep it safe from bumps, scratches, and drops. Think of it as your camera's superhero cape!

- Choose the right case: Look for a case that fits your camera snugly and has a sturdy design. You can find cases in all sorts of colors and styles, so you can pick one that matches your personality.

2. The Lens Protector: A Shield of Safety

- Why it's important: Your camera's lens is its eye, so it needs extra protection. A lens protector is like a pair of sunglasses for

your camera, shielding it from scratches and smudges.

- Choose the right protector: Look for a lens protector that is specifically designed for your camera model. Make sure it fits securely and doesn't interfere with your photos.

3. The Tripod: Your Camera's Best Friend

- Why it's important: A tripod is like a steady hand for your camera. It helps you take sharper photos and videos, especially in low light or when you're taking self-portraits.

- Choose the right tripod: Look for a tripod that is lightweight and easy to carry. Make sure it's tall enough to get the angle you want for your photos.

4. The Battery Buddy: Keep Your Camera Juiced

- Why it's important: A dead battery is like a car without gas. It's no fun when your camera runs out of juice.

- Take care of your battery: Charge your battery fully before using it for the first time. Avoid leaving the battery in the camera for long periods when it's not in use.

5. The Safe Zone: Where Cameras Thrive

- Avoid extreme temperatures: Cameras don't like hot or cold weather. Keep your camera away from direct sunlight, heaters, and freezing temperatures.

- Watch out for water: Cameras don't like water either. Keep your camera away from rain, pools, and spills.

- Protect from drops: Accidents happen, but you can prevent them by being careful with your camera. Avoid dropping it or letting it slip from your hand.

6. The Cleaning Crew: Keeping Your Camera Sparkling

- Use the right tools: Use a soft, microfiber cloth to gently wipe away smudges and fingerprints from your camera's lens and body.
- Avoid harsh chemicals: Never use alcohol, solvents, or other harsh chemicals to clean your camera. They can damage the delicate parts.

7. The Digital Detective: Check for Updates

- Stay up-to-date: Keep your camera's software up-to-date. This will help ensure

that your camera is running smoothly and has the latest features.

By following these safety tips, you can help keep your camera in top condition and enjoy taking amazing photos for years to come. Remember, a happy camera is a camera that's well-cared for!

www.ingramcontent.com/pod-product-compliance
Lightning Source LLC
LaVergne TN
LVHW051752050326
832903LV00029B/2870